W9-BUL-594

ORCA CHIEF

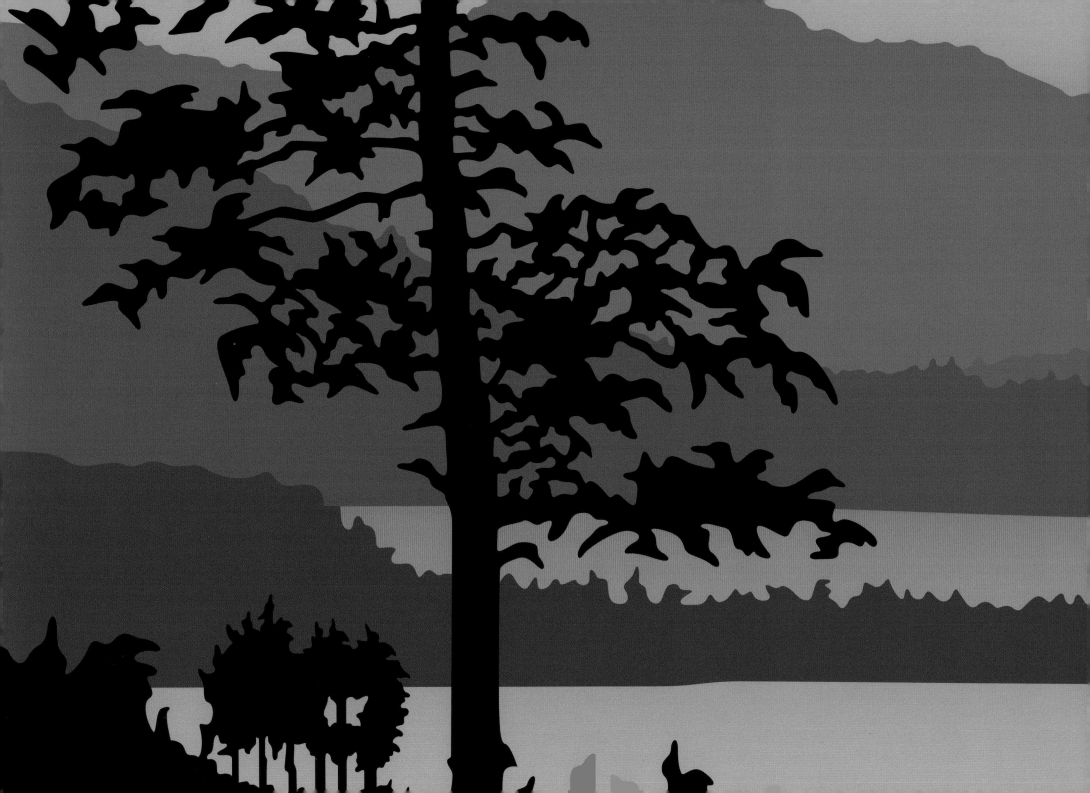

ROY HENRY VICKERS *and* ROBERT BUDD
Illustrated by ROY HENRY VICKERS

ORCA CHIEF

Harbour
PUBLISHING

Illustrations copyright © 2015 Roy Henry Vickers

Text copyright © 2015 Roy Henry Vickers and Robert Budd

2 3 4 5 6 7 — 19 18 17 16 15

All rights reserved. No part of this publication may be reproduced, stored in a retrieval system or transmitted, in any form or by any means, without prior permission of the publisher or, in the case of photocopying or other reprographic copying, a licence from Access Copyright, www.accesscopyright.ca, 1-800-893-5777, info@accesscopyright.ca.

Harbour Publishing Co. Ltd.

P.O. Box 219, Madeira Park, BC, V0N 2H0

www.harbourpublishing.com

Design by Anna Comfort O'Keeffe

Printed and bound in China

Harbour Publishing acknowledges the support of the Canada Council for the Arts, which last year invested $157 million to bring the arts to Canadians throughout the country. We also gratefully acknowledge financial support from the Government of Canada through the Canada Book Fund and from the Province of British Columbia through the BC Arts Council and the Book Publishing Tax Credit.

Cataloguing data available from Library and Archives Canada

ISBN 978-1-55017-693-3 (cloth)

ISBN 978-1-55017-694-0 (ebook)

Author's Note

This story was told to me by a man whom I called Ya-a Spencer. *Ya-a* in our language means "Grandpa." His first name was actually Kenneth and he was related to my great-grandmother, who was born a Spencer. In 1974 I completed my art education at 'Ksan in Hazelton and headed home to Kitkatla for a visit. I took some time getting in touch with the water and the land around my hometown. I liked to leave the village for a couple of days in a canoe with no food and no water—just a rifle, a fishing rod and a local dog that wanted to come along.

One day, on my return from such a trip, Ya-a Spencer invited me over for a visit. He was blind but he could see me with his vision. We went into his room where he had a wall full of books. And he said, "I can't read those books anymore. I read all of those books and in all of those books, there was not one story like the story I'm going to tell you." He asked me to sit down and he began to tell me the story of Orca Chief. He said, "The story belongs to your grandmother's family and one day you will be able to tell it to the people."

It is an honour to take my place in a line of storytellers and share my version of *Orca Chief*.

Roy Henry Vickers,
Hazelton, BC, 2014

Kitkatla is a small village near Prince Rupert on the northwest coast of British Columbia. My people have lived here continuously for over five thousand years and this is one of our old stories, handed down for generations.

In the old days, four men set out from Kitkatla to paddle to their food gathering place, known today as the Estevan Group. It was spring, the time to gather seaweed and fish for sockeye salmon.

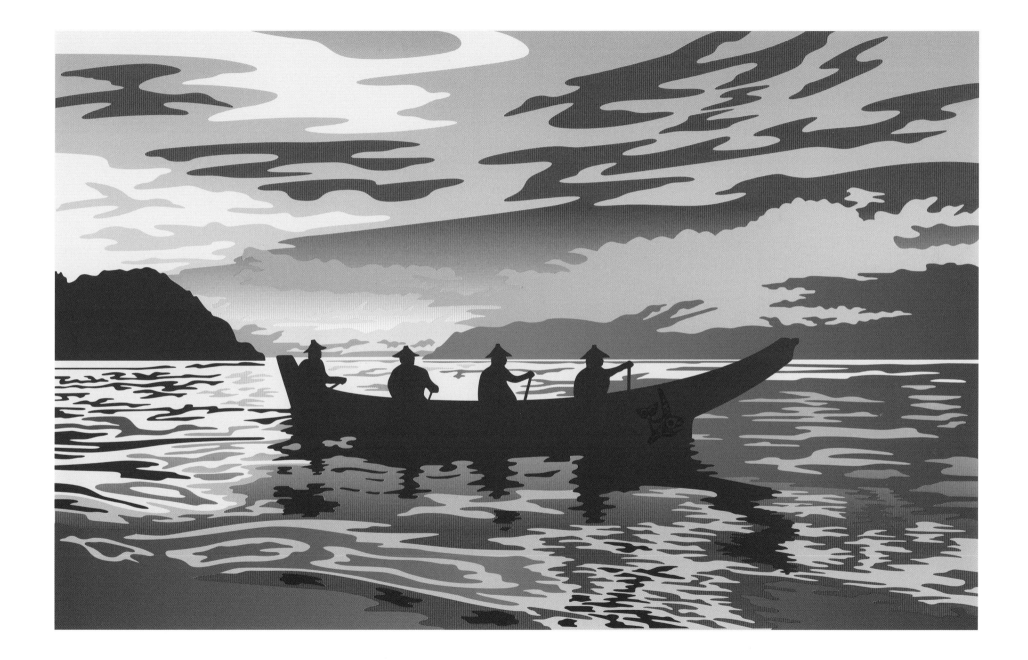

It was a long paddle and when the men arrived, they wanted to drop their anchor and sleep. In those days, an anchor was a big, heavy rock with a hole carved through it and a cedar-bark rope tied through the hole. The men were so sleepy, they just threw the anchor over the side. They didn't say a prayer. They didn't ask that the anchor find a safe place to land on the bottom of the ocean.

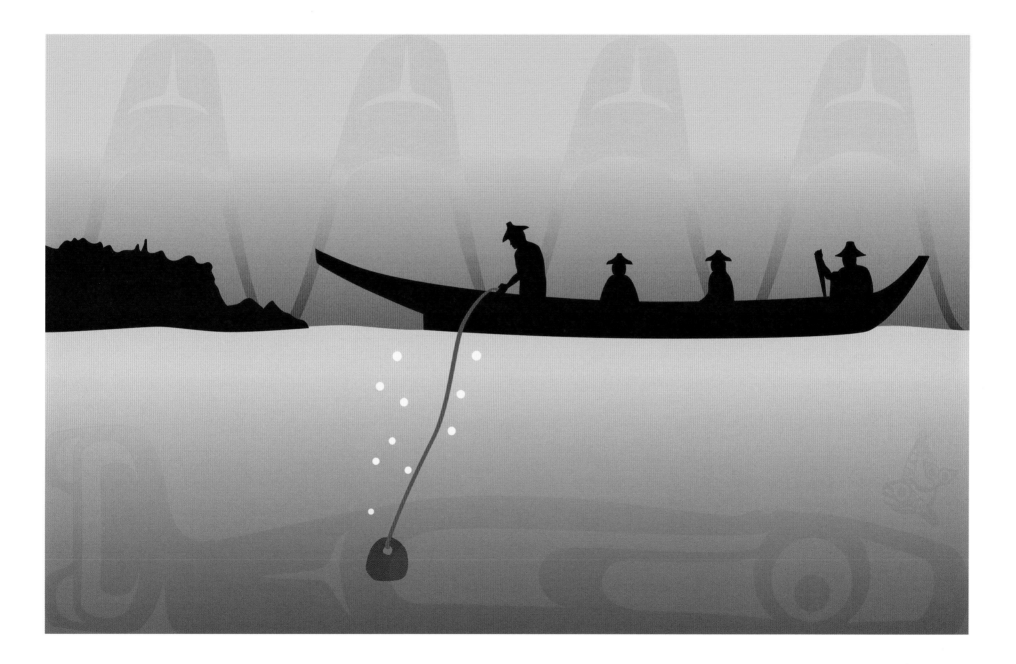

Well, that anchor did not land quietly on the ocean floor. It landed on the roof of the underwater house belonging to the chief of all the orca. The anchor made such a loud bang that Orca Chief said to one of his helpers, a little ratfish, "Swim up and find out who is up there and why they dropped a rock on my house."

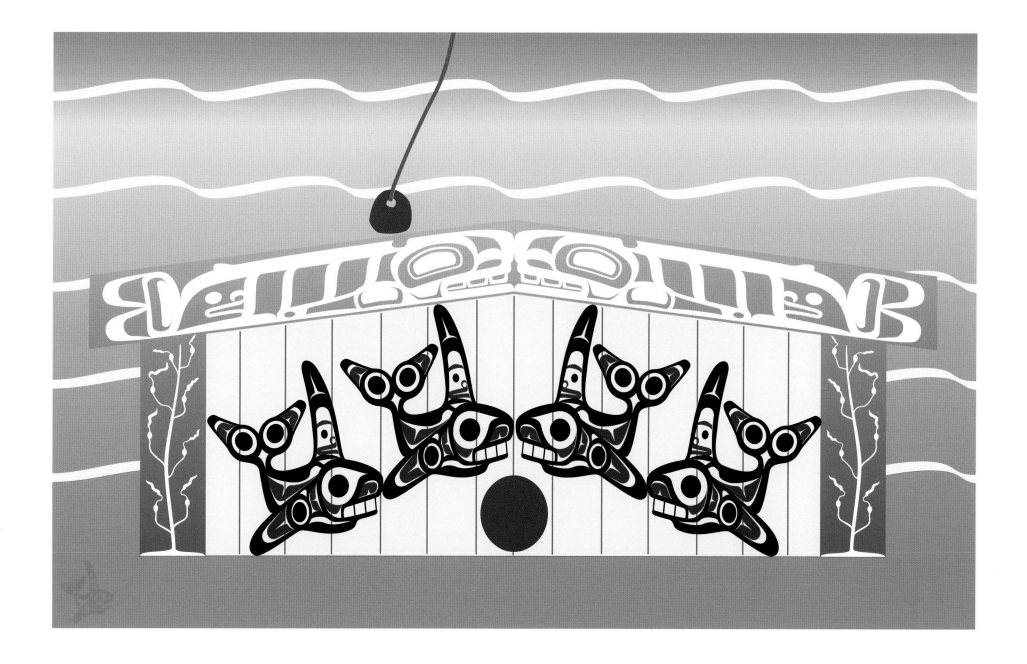

So Ratfish went up to the ocean surface and he saw the canoe. Curious, he swam around and around, with his tail slapping the sides of the boat. The noise woke the sleeping men and one grumpy hunter reached over and grabbed Ratfish, pulled his fins off and threw him back in the water. Poor little Ratfish swam back down and told Orca Chief about the bad people on the surface.

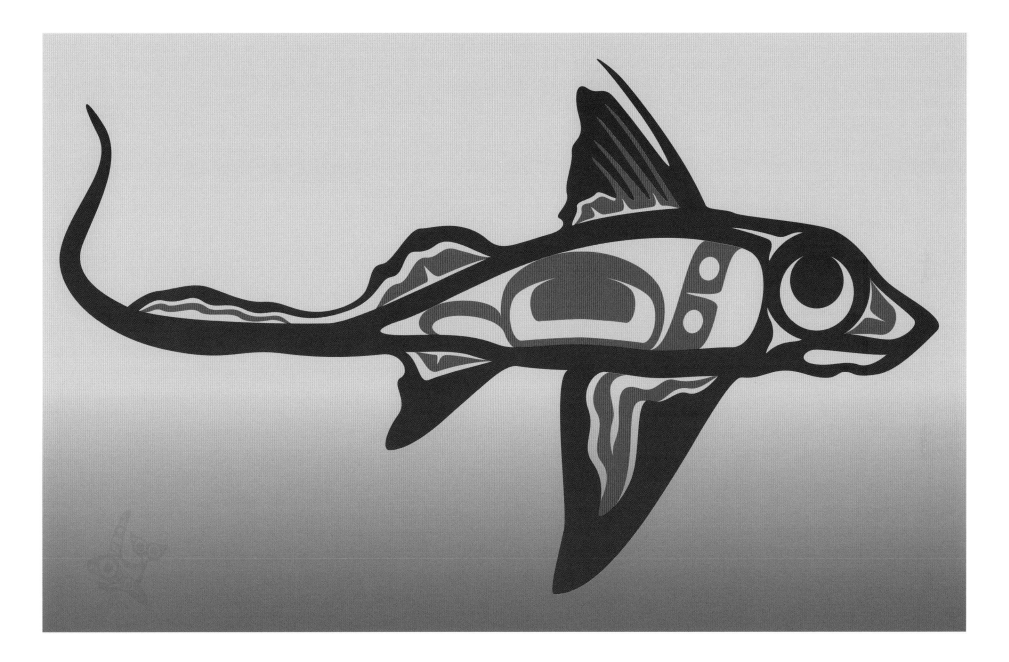

Orca Chief became very angry. He sent two of his best warriors to the surface, telling them, "Bring those people down to my house."

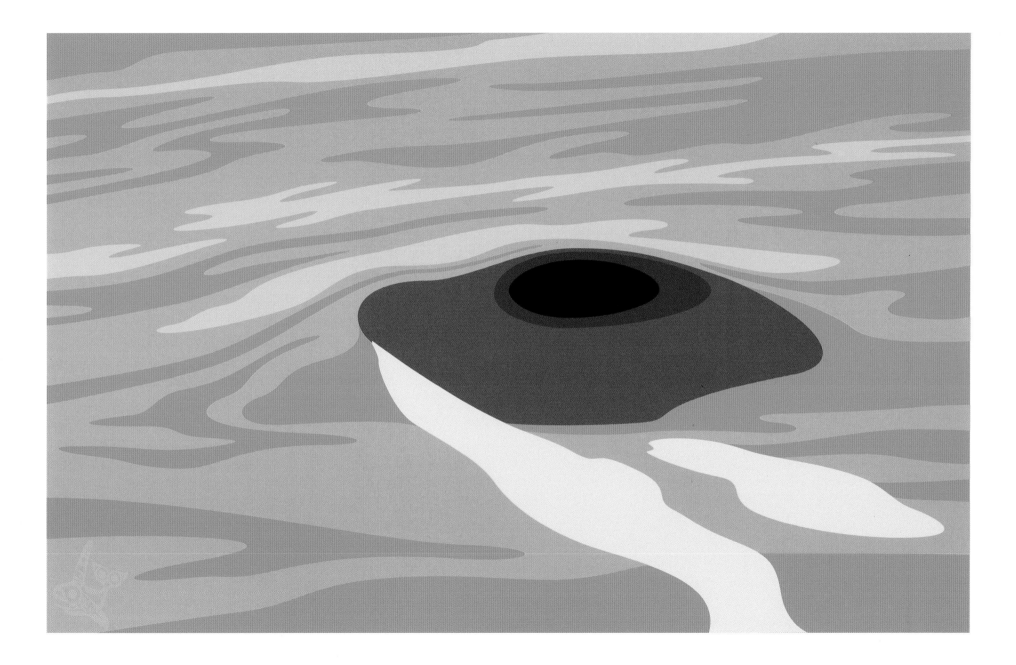

So the two orca swam around and around and around and around, faster and faster and faster and faster, until they caused an enormous whirlpool that sucked the canoe right down

down

down

to the bottom of the sea and through the door of the big house belonging to Orca Chief.

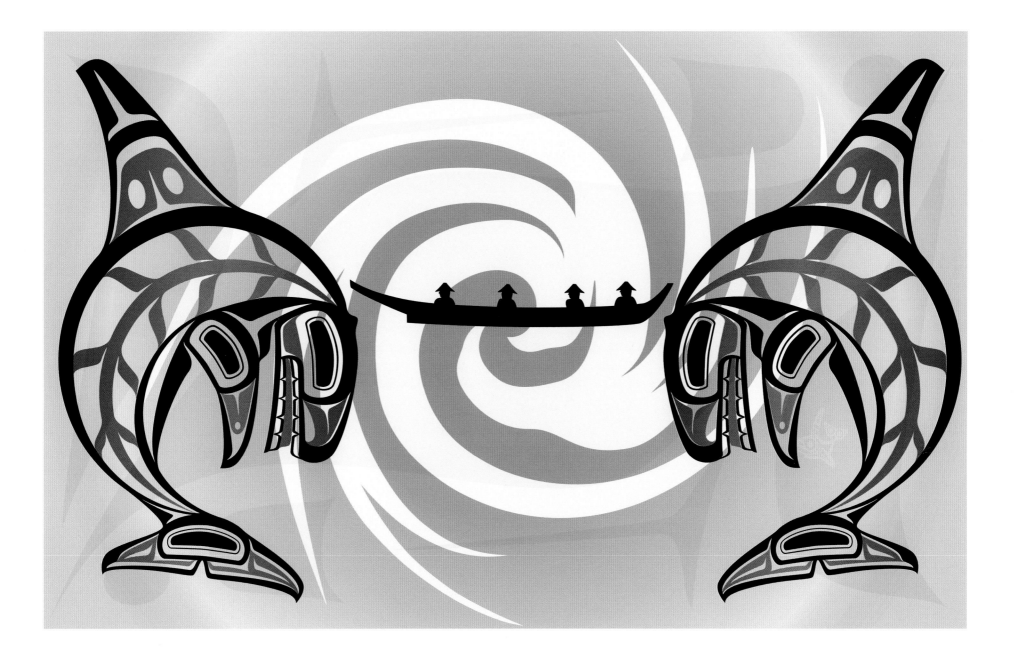

Then all was quiet.

The canoe, with the four surprised men in it, sat on the floor of the big house. Orca Chief looked at the men and asked, "Why would you drop your anchor on my roof? You should act with more respect in this world."

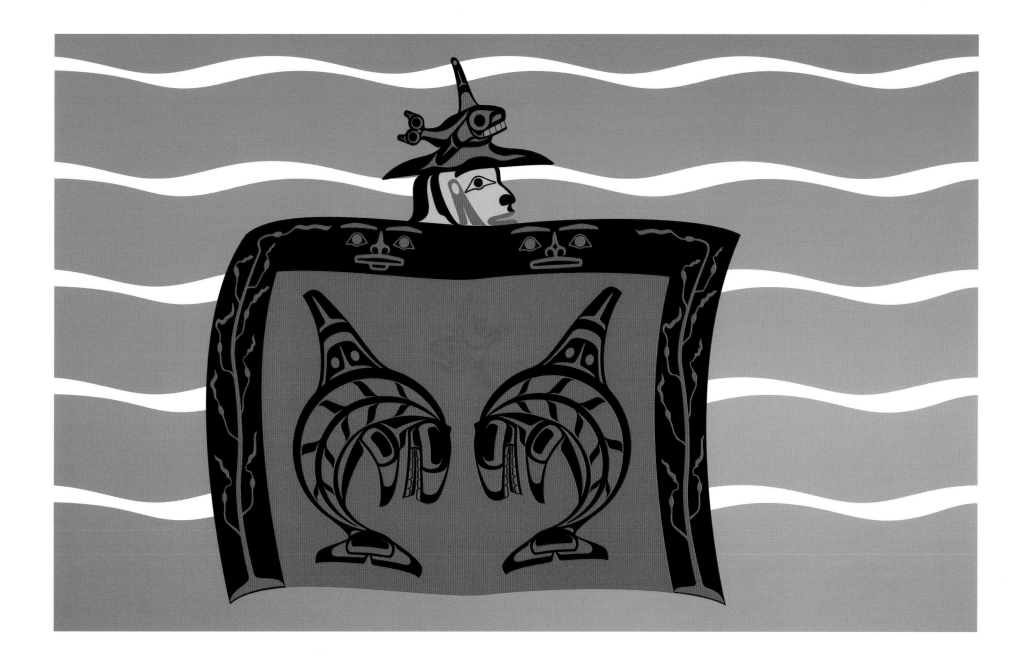

The men were scared of the fierce-looking whale and they started crying. They begged the chief, "Please! Have pity on us. We were tired. Yes, we were disrespectful, we are so sorry. We didn't know you had a house down here. We will learn to be more careful. We will learn!"

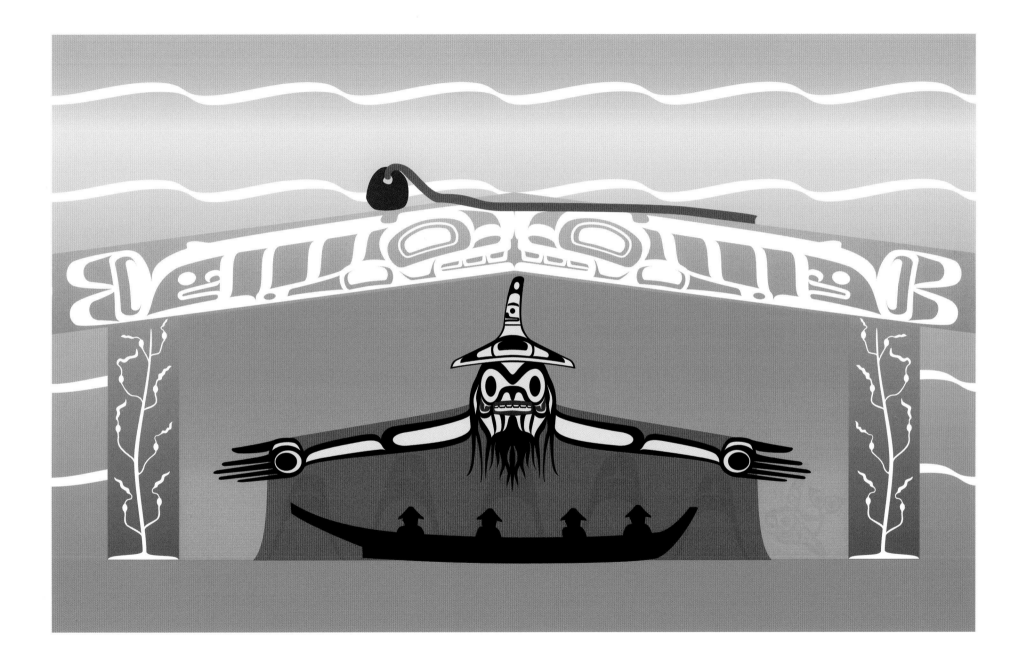

Orca Chief was kind, so he asked two of his best hunters to take these men and show them the ocean. He said, "Show them all of the food, even the little sea cucumbers that move slowly on the ocean floor. Tell them what is good to eat."

Most importantly, he instructed the men, "Always give thanks to those things that are going to become your food."

Then the orca hunters took the men on an adventure and showed them all the beautiful things as they travelled through the undersea world.

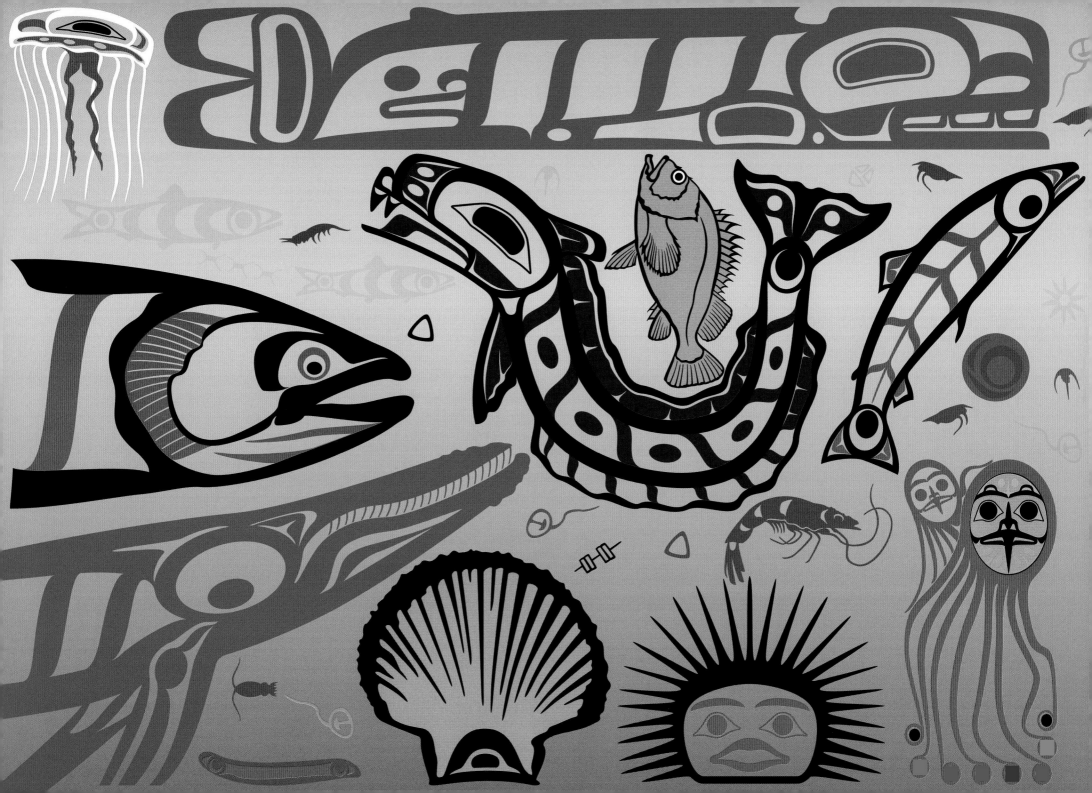

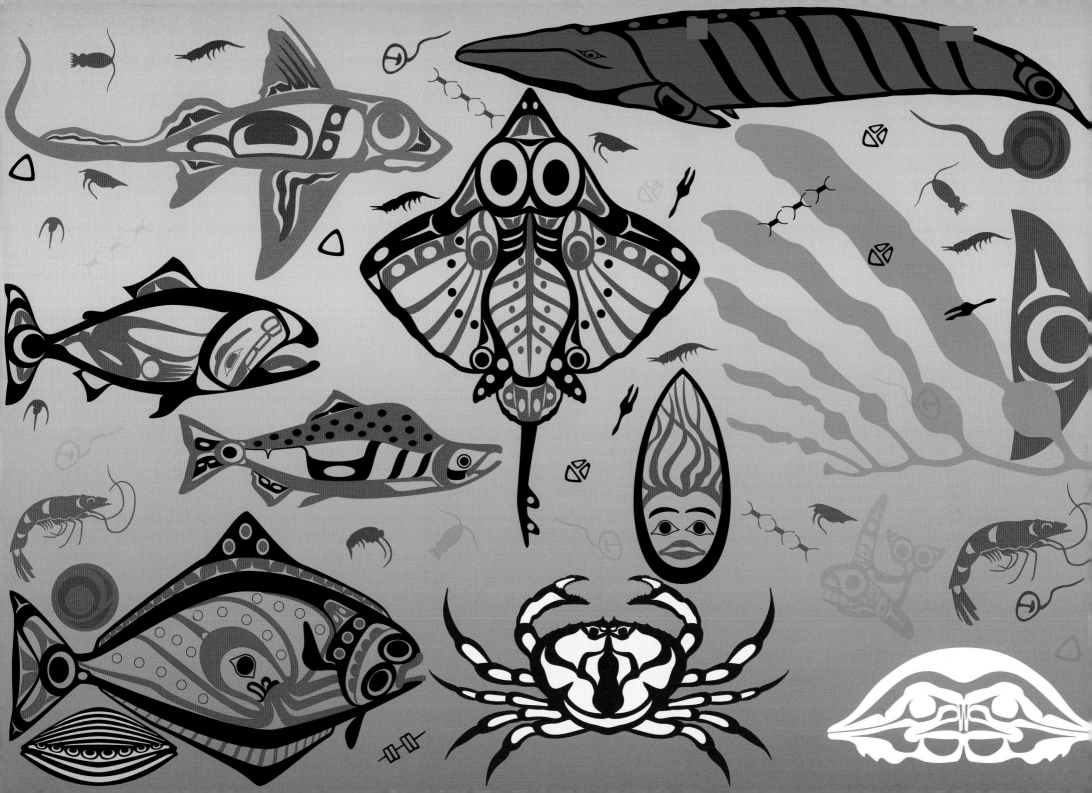

The whales showed the men that when the tides stop coming in and start going out, everything slows down. This is the best time to catch halibut, ling cod and red snapper.

Then the orca took the men to an island with a shallow bay shaped like a saucer, with a creek flowing into it and they saw how the many huge, beautiful crabs followed the tide.

The men took their paddles and held them out to the crabs. The crabs bit the paddles and the men lifted them into the canoe and gave thanks.

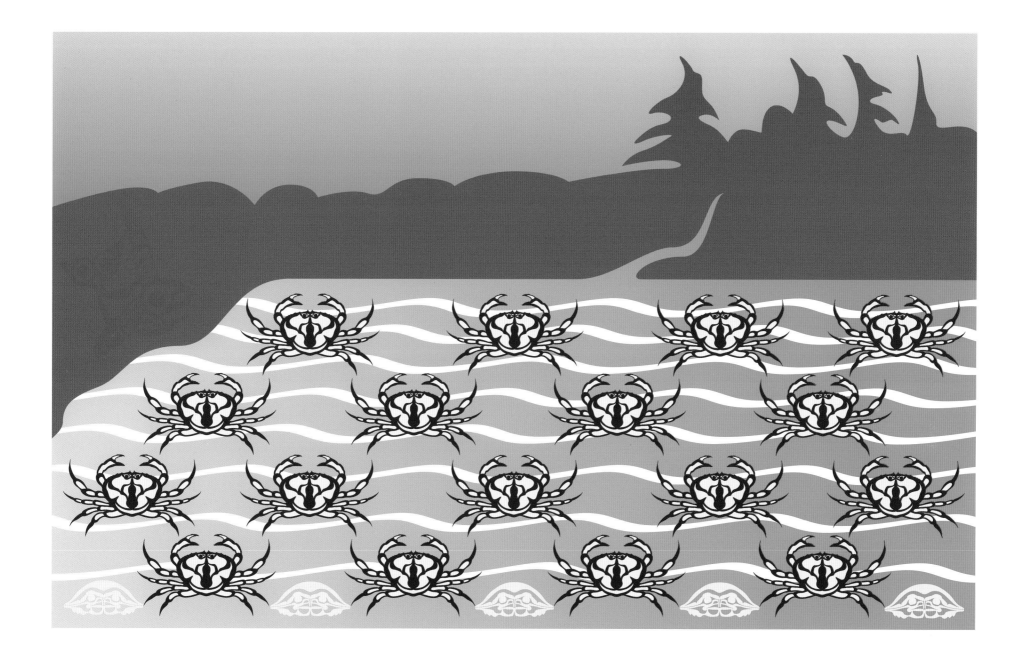

The orca then brought the men to the place where the Skeena River meets the Pacific Ocean and showed them where the oolichan come in the spring. The orca explained, "You can also call these 'candlefish,' because when they are caught and dried you can light them on fire, they are so rich with oil."

The oil would become an important part of the diet of the people and so valuable they would trade it all over the world.

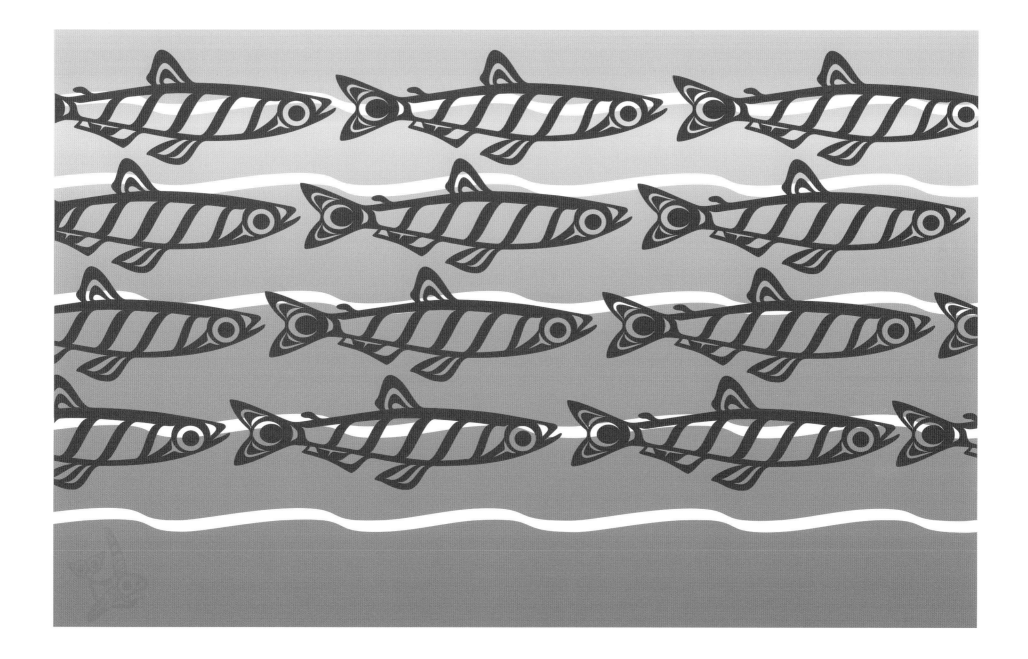

Beyond, the men could see a pod of humpbacks working as a team, surrounding a school of herring. The whales swam in a circle and blew bubbles, keeping the thousands of fish together. As they swam around and around, the circle got smaller and the herring were forced closer together, into a shiny silver ball.

When the wise female of the group decided it was time, she let out a loud call which blew bubbles underneath the herring, forcing them to the surface. It was as if she were saying, "Okay! Come and get it!" She was the oldest mother and it was her job to make sure her family had enough to eat. At her call, the whales swam under and scooped up the herring in their open mouths.

As the men watched this family, they remembered their own mothers calling them for dinner, and they smiled as they imagined the hugs they would share once they returned to the village.

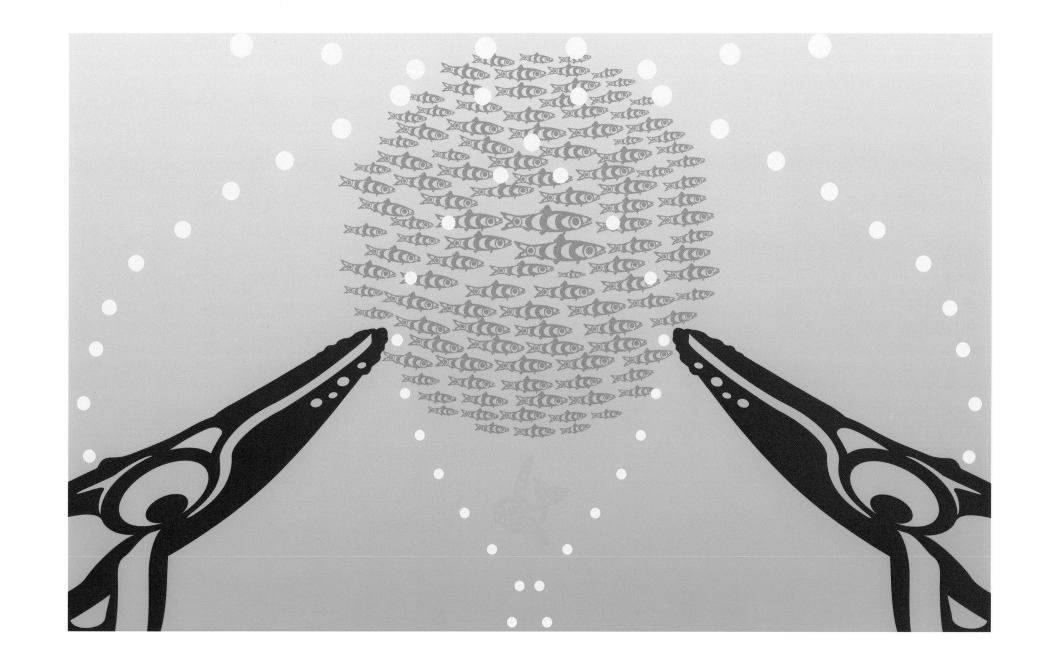

After many more lessons, the Kitkatla men were taken back to the surface. Much time had passed and it was now the middle of summer. The men sang songs and paddled with a new respect for all that lived below the surface.

As they travelled through a wide channel between two islands, they heard loud squeals and saw their friends coming to say goodbye.

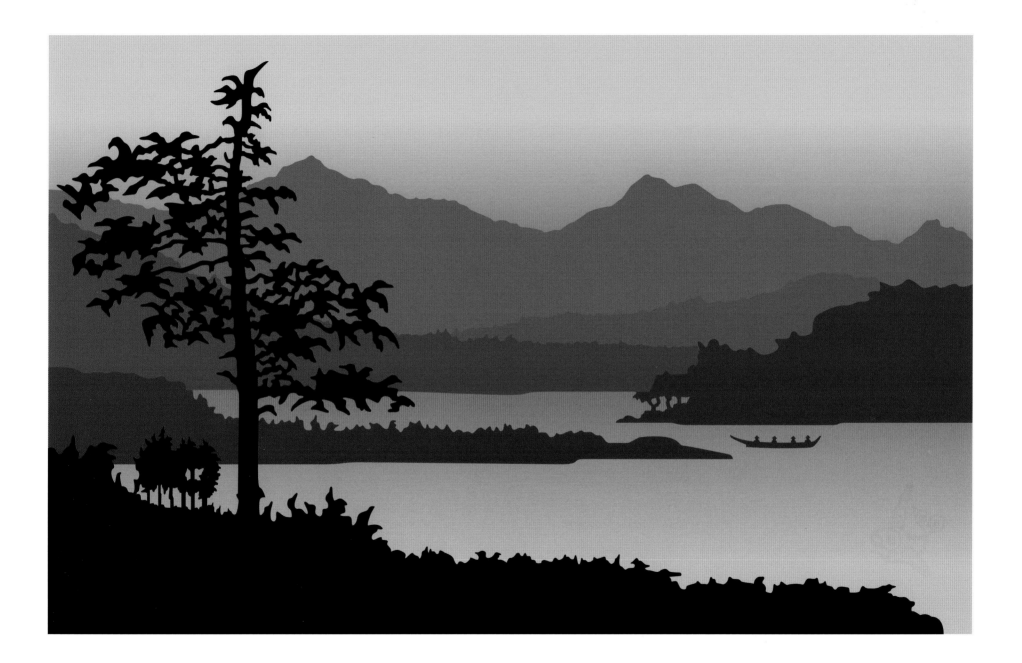

Ten orca clans came to celebrate, playing and jumping out of the water, bringing their children to show them the majesty of the world above.

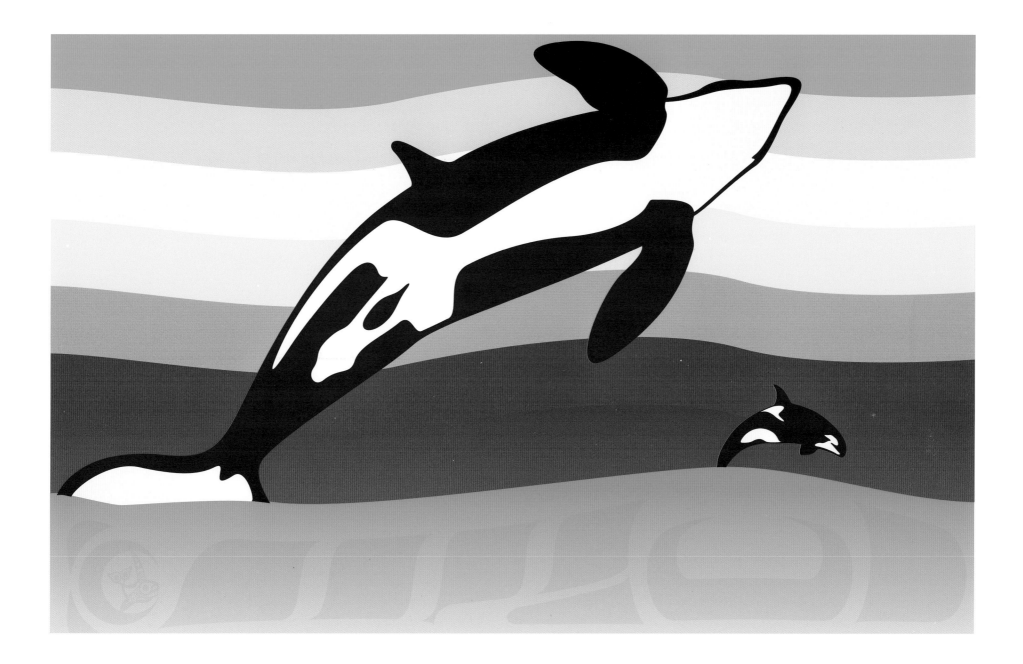

In the middle of this joyful gathering, the men remembered that they had promised to bring back food to their village. They had been gone a very long time, but their canoe was still empty! So they decided to try out what they had learned. They remembered that whenever the orca approached, all the fish would scatter and hide.

They paddled their canoe away from the orca, toward a large kelp bed near the rocks. The kelp were as tall as trees and firmly anchored to the bottom.

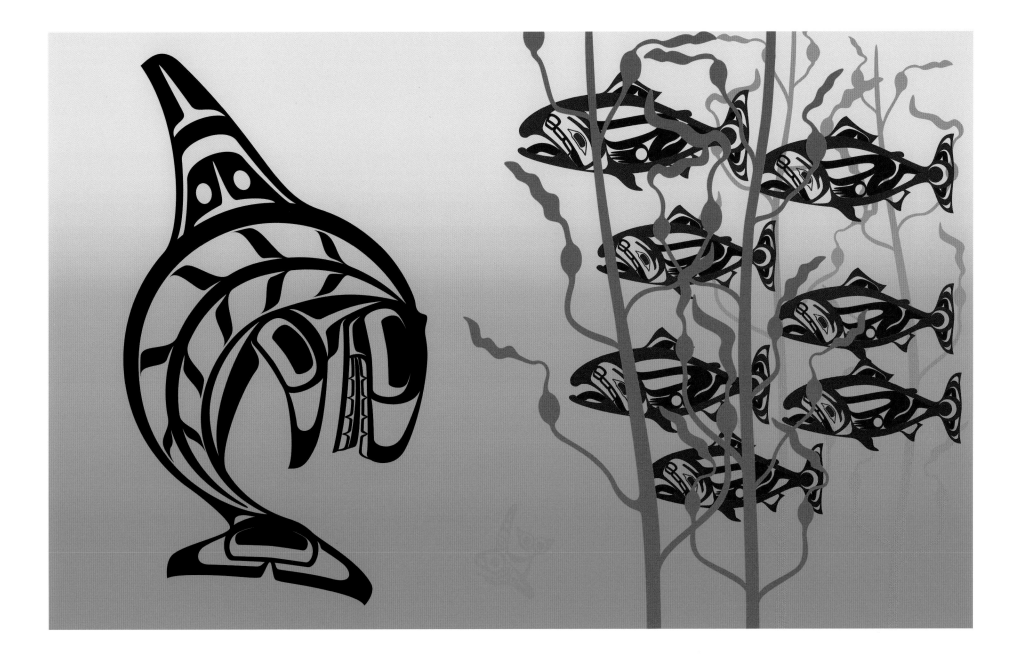

The men cast out their net and waited with great excitement. They knew the fish would hide in the kelp forest, away from the dancing, splashing orca.

Suddenly, whoosh, the whole net went under water. When they pulled the net in, it was full of fish.